# Basic
# Scanning Guide

## FOR PHOTOGRAPHERS AND
## OTHER CREATIVE TYPES

## ROB SHEPPARD

AMHERST MEDIA, INC. ■ BUFFALO, NY

Published by:
Amherst Media, Inc.
P.O. Box 586
Buffalo, N.Y. 14226
Fax: 716-874-4508
www.AmherstMediaInc.com

Publisher: Craig Alesse
Senior Editor/Production Manager: Michelle Perkins
Assistant Editor: Barbara Lynch-Johnt
Assistant Editor: Matthew Kreib

ISBN: 1-58428-039-5
Library of Congress Card Catalog Number: 00-132626

Printed in United States of America.
10 9 8 7 6 5 4 3 2 1

# table of contents

# introduction

With scanner prices at all-time lows, scanners have become a computer peripheral that every photographer can use. This book is designed to help you understand how a scanner works and how to best use one with your photography. You will see lots of photos, both of the physical objects like a scanner, and of actual screen shots from the computer. We've tried to show you key features on scanners and in the screen shots, so that when you use your scanner, you can look for similar things. Unfortunately, scanner manufacturers have not standardized anything for scanner drivers (the software that makes them work).

We've also included a little about how to deal with the scan immediately after the scanner has done its work. Scanning really continues into the software. A good scan requires practice, both in setting up the scanner, and in working with the scan after the physical part of the scanning is complete. We've included screen shots of several types of software so you can get an idea of what is possible. The top-of-the-line image processing software that everyone talks about is not a necessity for getting good photographs from your computer. There are many excellent programs available that will suit the average photographer quite well.

Use this book as a reference, and then start scanning! The best scans are yet to be made, and the more you try it, the better your photography will get.

## 1.

Scanning is a basic way of getting photos into a digital form so you can use them in a computer. Once you understand how to use a scanner, the possibilities for improving your photography are endless.

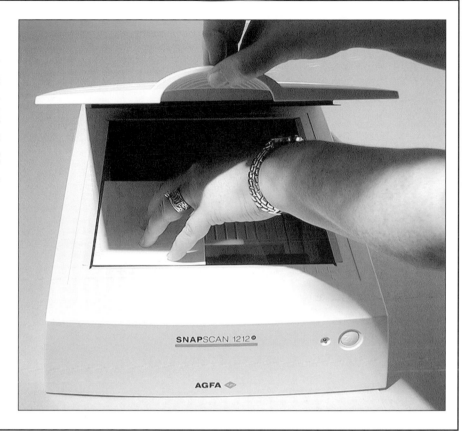

## 2.

Digital cameras are becoming increasingly popular ways of capturing digital images. However, the scanner has some great advantages over a digital camera because you can use your existing photo equipment, you get a quality no digital camera under $10,000 can match today, and you obtain image tones and exposure tolerance unmatched by most digital cameras.

**3.**

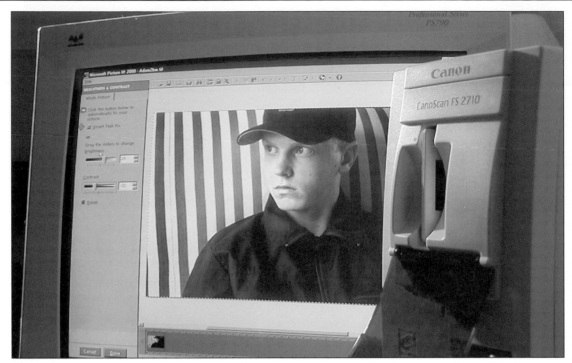

A scanner translates the multihued, multiple tones of a photograph, a slide, a negative or even three-dimensional objects into digital information that can be read by the computer. It passes light across or through the photo or object, then reads that information from the reflection or transmission of the light to a light sensor made up of many little "eyes" (dots per inch).

**4.**

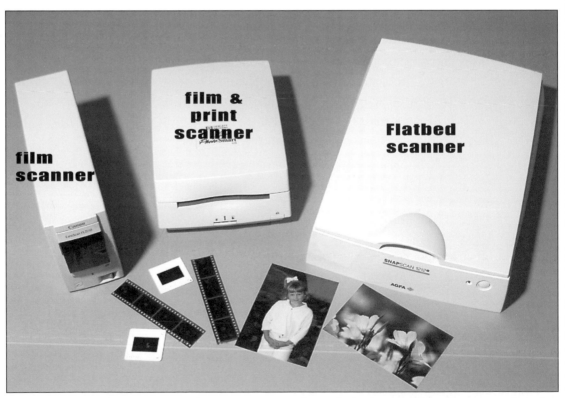

There are two basic types of scanners, one for solid objects like photographs, the flatbed, and one for transparent film like slides and negatives, the film scanner. Both can give excellent results.

## 5.

A scanner has four basic parts: a light to illuminate the photograph being scanned, a holder for the image, a sensor to "read" the photo, and electronics for translating what the sensor sees to digital data.

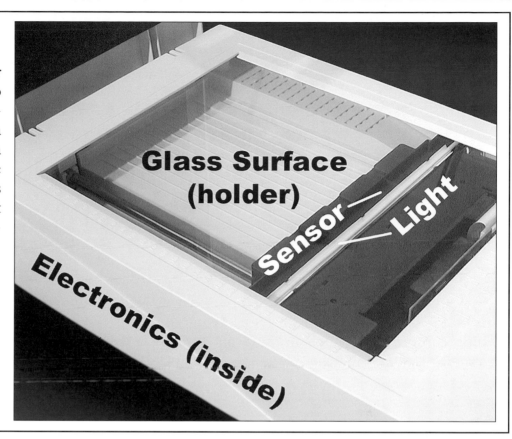

Glass Surface (holder)

Sensor

Light

Electronics (inside)

## 6.

The light from a scanner is generally a cold-light and will not harm an image. The light usually moves across the image as it is scanned. Some scanners use a fixed light source combined with mirrors and lenses.

## 7.

The sensor is critical; it is where the scanner "sees" the photo. The sensor consists of a row or rows of tiny light sensors called pixels (this can be a little confusing, since the parts of a final scanned image are also called pixels). A sensor usually moves very precisely across the photo, along with the light, so that the details in the image can be captured.

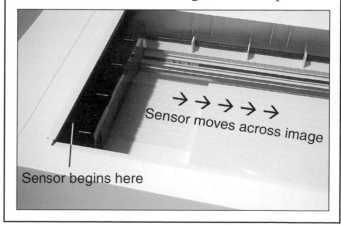

Sensor moves across image

Sensor begins here

# 8.

Original

Few pixels or
dots per inch

Many pixels or
dots per inch

How much detail a scanner can define is determined in part by its resolution. This is determined by the number of the pixels packed onto the sensor and is listed as a dots per inch (dpi) number. More pixels (higher dpi) mean more detail that the sensor can capture. Smaller originals need higher dpi if they are going to be enlarged bigger than the original.

# 9.

Resolution on flatbed scanners is sometimes given as two numbers, such as 600x1200. The first number is the sensor dpi. The second is based on how the sensor moves, or "steps," across the image. If it moves in whole steps, there is one number. If the movement is in 1/2 steps, the second number is doubled, and so forth. Stepping does give the scanner more data to capture, but is not as good as a higher dpi at the sensor.

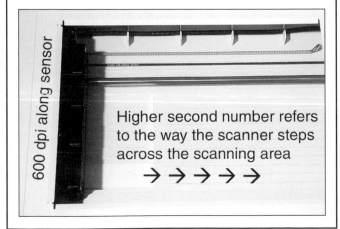

600 dpi along sensor

Higher second number refers to the way the scanner steps across the scanning area
→ → → → →

# 10.

Color Depth & Density Range --
How scanner translates colors and tones

The detail a scanner can see is also affected by how well it can discern colors (color depth) and by how clearly it can see differences between shades of gray (its density range). Most scanners today have a good color depth for photography, however, more expensive scanners typically can capture a greater density range. This can be especially important for slides and contrasty images.

## 11.

If most of your scanning will be done from photographic prints, you will need a flatbed scanner. Today's flatbeds offer a lot for a very low price. They can also be used to scan your kid's drawings, and even small objects, making the scanner almost like a dedicated digital camera.

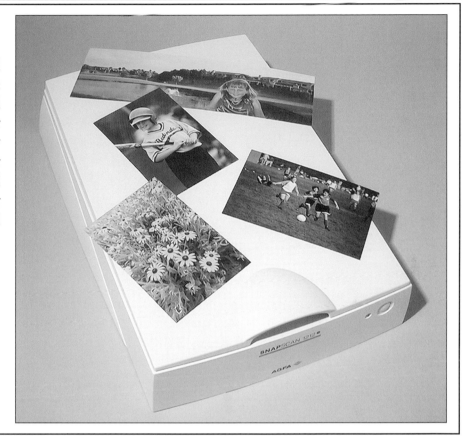

## 12.

If most of your scanning will be from slides or negatives, you will need a film scanner. Film scanners are more expensive than flatbeds, but potentially offer the highest image quality for the photographer. The slide or negative is the original image as made by the camera, and typically holds more detail and sharpness than a print. Consequently, a film scanner has more information to work with in making the scan.

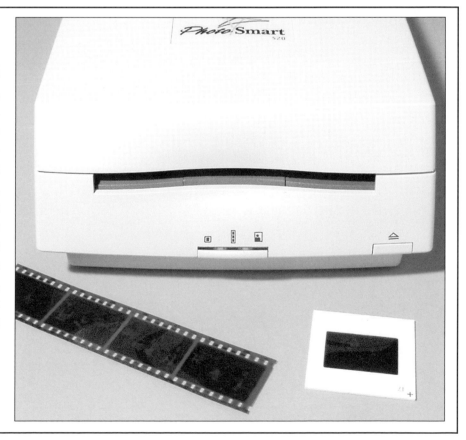

**13.**

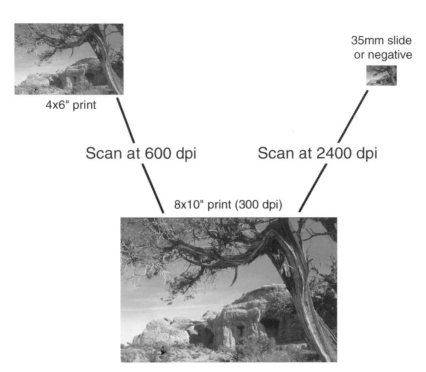

4x6" print

35mm slide or negative

Scan at 600 dpi          Scan at 2400 dpi

8x10" print (300 dpi)

Resolution is very important in selecting a scanner. Most photographers will find a flatbed that offers 600 dpi sufficient for most needs, giving a 4x6-inch print the potential of being printed at 8x10. A film scanner that features 2400-2700 dpi can provide digital files capable of printing out as an 8x10 image.

**14.**

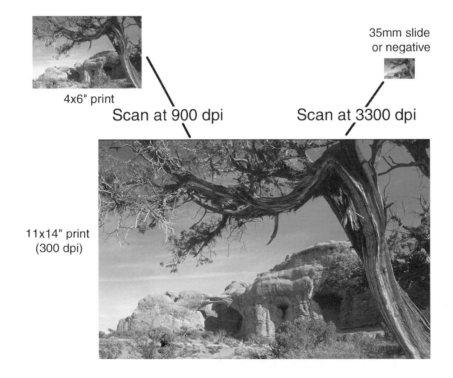

4x6" print

35mm slide or negative

Scan at 900 dpi          Scan at 3300 dpi

11x14" print
(300 dpi)

Large prints need large image files and usually higher resolutions from a scanner. To scan a 4x6-inch print to make an 11x14, for example, you'd need a dpi close to 900. For a 35mm negative to be used for a 11x14 print, you'd need a film scanner with a dpi of over 3000.

# 15.

Scanners definitely do their jobs at different speeds. One thing that makes comparison difficult is that a lot of a scanner's work is done by the computer, so scanning speeds will vary from computer to computer. Still, if you need the fastest speeds, do some comparisons and expect to pay more.

# 16.

Scanners connect to the computer in a number of ways. The least expensive is through the parallel port. Many flatbeds work this way. This connection is usually fairly easy to set up (unless you have conflicts with the printer), but it is also the slowest link.

# 17.

An increasingly popular way of connecting the scanner is through a USB port. These are very easy to use, you literally just plug in the scanner, install the software and you're off. You can plug in and out as needed. The data transfer through USB is much faster than with a parallel port, but your computer must have a USB port.

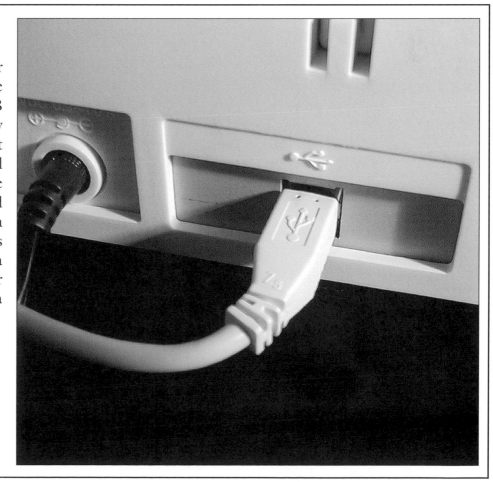

# 18.

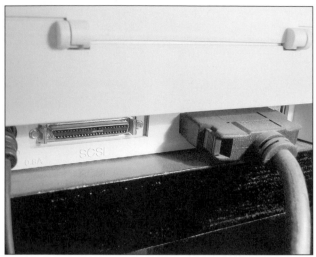

The fastest scanner connection is through a SCSI port. Almost all film scanners work this way. It is a little more complicated in that you usually have to add a SCSI board to your computer, but if you are working with big photo files needed for larger prints (8x10 or larger), a SCSI connection can speed things hugely.

# 19.

Scanners typically come packaged with two types of software: one is the scanner driver, the other is some type of image processing software. Scanner drivers vary a bit in how their interface works, but few manufacturers show you this on the box. If you can see it in operation at a computer show, or you can check a web site, you can often get an idea if you like the style of the interface or not. Usually, a manufacturer's interface is pretty consistent throughout a product line, at least within a type of scanner.

# 20.

Some scanners come with special features, such as special scanning enhancement software, digital scratch and dust clean-up or OCR (optical character reader—for text scanning documents and turning them into digital files). These may or may not be useful to your particular situation.

## 21.

Almost every computer available today is capable of working with a scanner and the image files that result from scanning, whether Windows or Mac. The faster the computer processor (Pentium, Athlon, etc.), the faster the processing of the scan will go (and the easier it will be for you to work with larger images). But don't be dismayed if your computer is not the latest and the greatest. It may take more time working, but it will probably still get you there.

## 22.

RAM is always critical to image work in a computer. Without enough RAM, which is the active memory of the computer, scanning and other photo work can get bogged down and even crash the computer. You should have at least 64 megabytes (MB) and more is better. You are actually better off with more RAM and less processing power if your budget is limited.

# 23.

If the scanner is the front end of the photo work in the computer, storage is the back end. Image files take up storage space! As you scan more and more photos, you'll wonder what happened to the open space on your hard drive. A many-gigabyte hard drive will quickly become a necessity if you don't have one already. Luckily, they are fairly inexpensive and can be added to your computer when needed.

# 24.

There will be times when you want to take your scans to another computer, to take your photo files to a lab for a special print or just to store images in a particular project so they stay together and don't take up space on the hard drive. CD-R and CD-RW drives are an excellent way to do this, as the disks offer over 600 MB of very sturdy storage. Plus, they can be played in nearly any computer.

# 25.

Other good removable storage for photos include Zip disks and SuperDisks. These offer 100-250 MB of storage, are easy to use and reuse, but do not have the longevity of a CD.

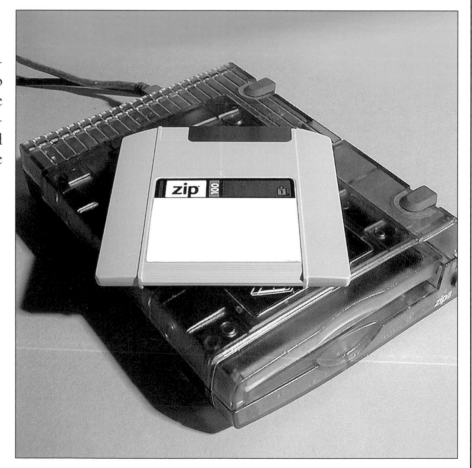

## 26.

One of the first things you must do is to figure out where to put your scanner. Keep the scanner near to your working area so you don't have to keep getting up and down to adjust things on your scanner as you work. Use the cable that came with the scanner—adding a longer cable can sometimes cause problems.

## 27.

Follow the directions in the manual carefully in setting up the scanner. There are enough idiosyncrasies among individual scanners that general instructions can't be given.

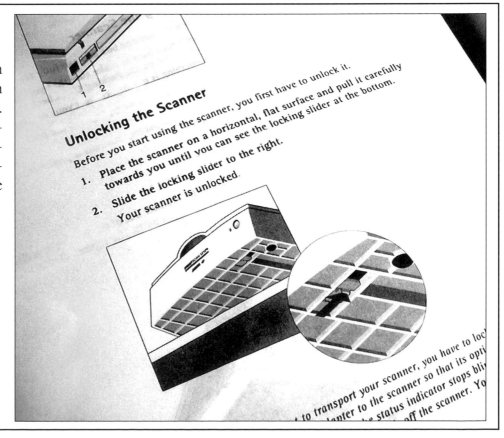

## 28.

For most scanners, you will need to turn them on before starting the computer. The computer needs to recognize the scanner as it starts up. If your scanner uses a USB connection, you can turn it on only as you need it as the computer will recognize it as soon as the scanner turns on or you plug it into the USB port. Some scanners have no switch and are turned on by the computer.

## 29.

Start the scanning process by placing your image in the right orientation on your flatbed or in your film scanner. Usually, the top of an image will go at the edge of the flatbed directly opposite the hinge (although a few scanners are hinged at the side).

# 30.

For a film scanner, the top of a slide or negative usually goes in first. You also need to check the front/back orientation. Usually, if it has the correct left-to-right alignment as you hold it, it will go in exactly that way. If you can't tell, find an image that you can, note how it is oriented, then use it as reference to match the correct side of a slide (or the lettering at the edge of a negative).

# 31.

Open up your scanner driver. This is the software that makes it work. On many scanners, you can open this directly and scan photos straight to a file on your hard drive. Usually, though, you'll want to scan into some image processing software. Some programs simply have a button or an icon to click that will launch your scanner.

# 32.

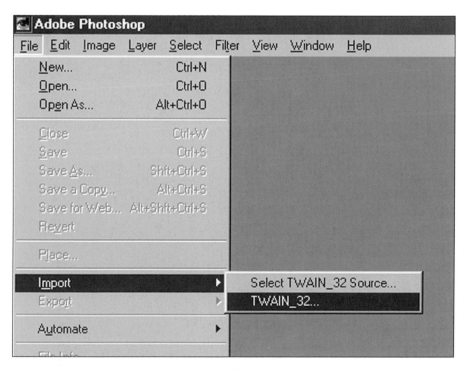

For some software, you'll need to go into your File menu and select "Import" or "Scanner." This will let you open the TWAIN driver, which is simply a specific way the scanner communicates with the software.

## 33.

Once the driver is open, you have some choices to make. It is always good to do as much as you can with the scanner driver. You want to get the best scan possible before you go to the image processing software. First, be sure the scan type matches your photo, e.g., slide, negative, type of print, etc.

## 34.

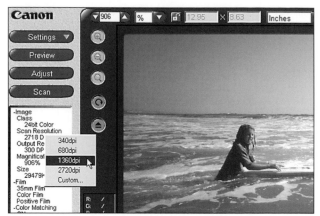

Setting resolution is a challenge (see the next section for more detail). This depends a lot on the size of your photo and the size of the final image. You want to scan at a high enough resolution to create a file with enough data to make your image the right output size. However, you don't want to scan too big or you will end up with a file that slows the computer down and clogs your hard drive.

## 35.

4x6" print needs approximately a 5 MB file

5x7" print needs approximately a 10 MB file

8x10" print needs approximately
a 20 MB file

Some rough guidelines can be given based on file size. An image file size tells you the amount of data available, which can in turn be adjusted according to your needs in the image processing software. For top-quality, photographic prints made on an inkjet printer, you will need these approximate file sizes: 4x6≈5 MB, 5x7≈10 MB, 8x10≈20 MB (uncompressed sizes).

# 36.

Once you've decided on the scanning resolution (and you may be doing some experimenting at first—that's okay), it's time to do a preview. Click on the preview button and let your scanner start to work.

# 37.

The preview is a very important step as it lets the scanner check the image and basically do a test scan for your approval.

# 38.

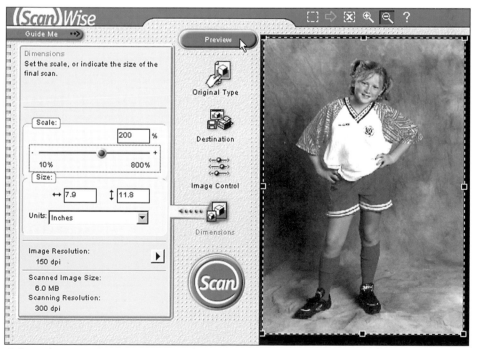

After the preview, you now have some choices before clicking on the final scan button. Examine the preview carefully to see if it looks like you want it to look (this is a creative choice, here, so go by what you like).

# 39.

Usually, you'll need to make some final adjustments. First, crop the scanning area so only the important part of your image will be scanned. Keep out edges of a slide, remove extraneous parts of a photo. Then recheck your output size, if needed, to be sure you are still getting the final scan size you need.

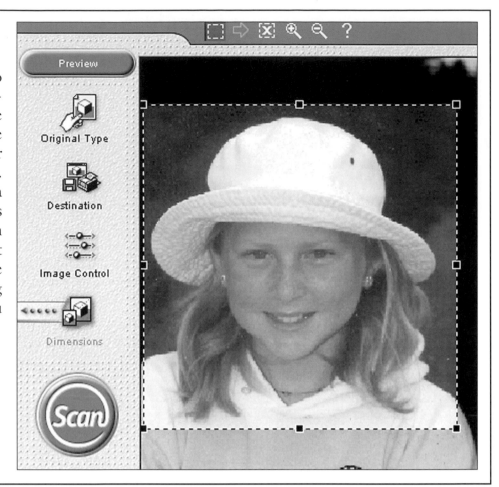

# 40.

Check the brightness and contrast of the preview scan. As you lighten or darken an image, you'll often need to adjust contrast as well. Watch your highlights (bright areas) to be sure they have detail and aren't burned out (assuming the original has detail there). Watch your shadows to see that detail is being scanned (again, if the detail is in the original).

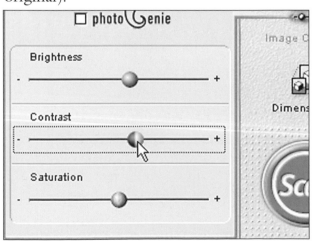

# 41.

Correct the color problems that you can. Sometimes your image will have a slight color cast or the scanner will adjust color incorrectly in the preview. You need to pull the color back to whatever looks best to you.

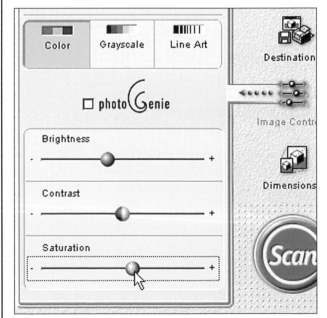

## 42.

Once you are satisfied with the preview, hit the scan button and let the scanner do its job. This can take mere moments or several minutes depending on the scanner and the power of your computer. Be patient—it's faster than running back and forth to the mini-lab!

## 43.

When the scan is complete, check to see how closely the preview matches the final scan. Usually, it will be very close, but for a variety of reasons, this doesn't always happen. In that case, try again, do the preview and make some new adjustments to compensate for the differences you see. Write down those adjustments (or save them if the scanner software allows it). You can use those adjustments in the future after making the preview to get the best scan of other images.

# resolution—
# math or consequences

## 44.

4x6 at 600 dpi

8x10 at 300 dpi

Resolution is a real slippery topic for photos in the computer, because it changes! We're not used to that, since the resolution of film or a lens is always a constant.

## 45.

To get the most out of your photos when using the computer, you have to understand how resolution works. After a little practice, you will be able to get prints from your computer that are as good as or better than traditional prints from a local processor.

# 46.

Poor quality prints will kill all of your efforts to make a great image, and frequently, the problem is resolution, which all starts at the scan. The wrong resolution will mean photos without enough detail, pictures that don't quite look sharp, and jaggy edges to lines.

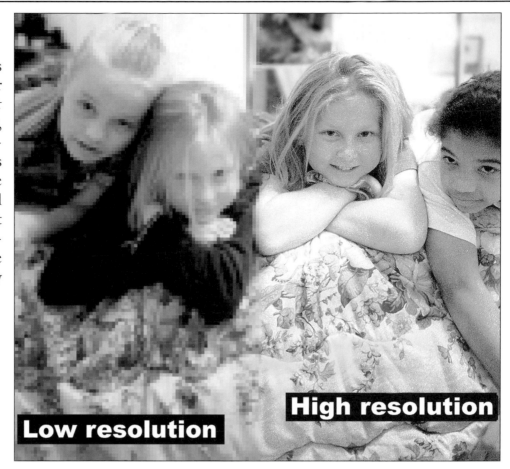

**Low resolution** — **High resolution**

# 47.

The dpi of a scanner directly affects more than the image quality. It also influences the settings that can be used on the driver and the speed of the scanning.

dpi -- dots per inch

Image Quality — Driver Settings — Speed of Scanning

# 48.

After making your scan, the resolution influences the storage needs of your computer (big files from high resolution scans need space), your computer's processor (larger resolution files require faster processors if you want to keep processing times down) and high resolution files need more RAM.

# 49.

4x6" at 300 dpi

1200 pixels

1800 pixels

Photo resolution in the computer requires two numbers: the dpi (or dots per inch) and the size of the photo (in inches). Giving one without the other is meaningless. You can also multiply them together to get the total number of pixels in a photo.

# 50.

## Same area resolution (20 x 20 total pixels), different dpi resolution

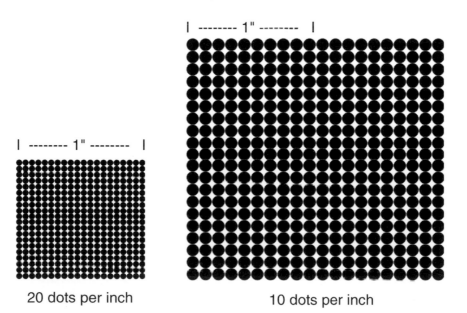

| -------- 1" -------- |

20 dots per inch

| -------- 1" -------- |

10 dots per inch

Dpi (e.g., 300 dpi) is resolution by a defined dimension, how many pixels fit in one inch. The dpi of a scanned image can be changed in the file to move pixels closer or farther apart (making the photo bigger or smaller).

# 51.

Area resolution (e.g., 1600x1200) is resolution per a defined area and represents the actual finite number of pixels that reside in the photo. This finite number can be reduced, but is not easily increased. It tells you the potential sizes at which the file can be used.

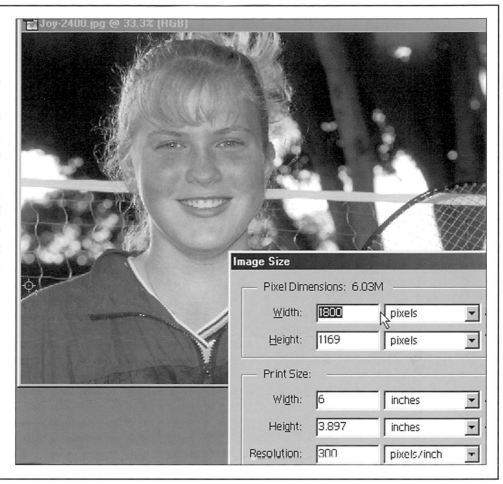

# 52.

The resolution of a scan will be somewhere on your scanner driver (software). To be able to set this properly, you need to have an idea of the final sizes you will be needing from your scanned image. You can always make the resolution of an image smaller. Making it bigger can be a problem.

# 53.

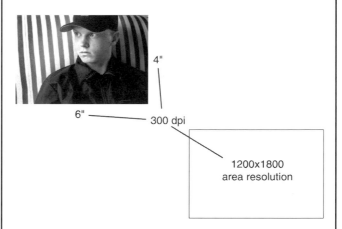

Many scanner drivers will give area resolution. You can also figure it out if you know the dpi and the size of the image being scanned—multiply the dimensions of the photo by the resolution, e.g., a 4x6-inch print scanned at 300 dpi is 4x300=1200 and 6x300=1800 or 1200x1800.

## 54.

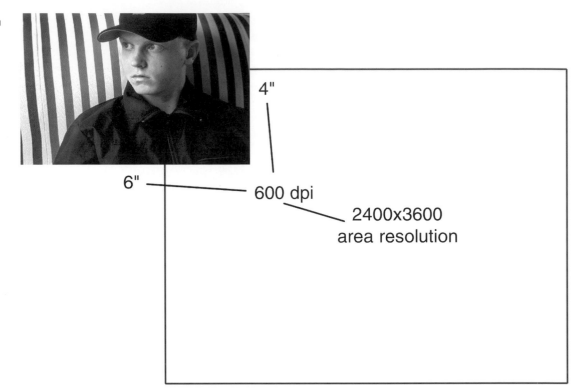

4"

6"

600 dpi

2400x3600
area resolution

If the same print were scanned at 600 dpi, the results would be 4x600 = 2400 and 6x600 = 3600, or 2400x3600—a file with considerably more data.

## 55.

For 35mm, the numbers are greatly changed because the image is so small. Let's say your slide scanner reads the 1x1.5-inch image at 2400 dpi. The results would be 1x2400 = 2400 and 1.5x2400 = 3600 or 2400x3600.

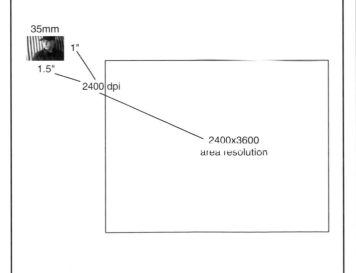

35mm

1"

1.5"

2400 dpi

2400x3600
area resolution

## 56.

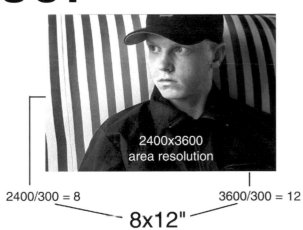

2400x3600
area resolution

2400/300 = 8

3600/300 = 12

8x12"

Scanned images have a fixed pixel dimension (area resolution). From that, you can figure out how big a scan can be used by dividing the dimensions by the desired dpi (as determined by your inkjet printer, a lab or service bureau, etc.). An image that is 2400x3600, and then printed on an inkjet printer (at 300 dpi for the image, not to be confused with the inkjet's dpi), is 2400/300=8 and 3600/300=12. The image can be 8x12-inches.

# 57.

Scanning a photographic print directly is one of the easiest ways of working with photography and the computer. The print allows you to see the image very easily before scanning so you have a good idea of what it should look like, plus you are sure you have the right image to start.

# 58.

Scanning from a print can also gives you a very big image file potential. Such large files can be important for making very large prints from digital files. Scanning from a good 8x10 at 600 dpi, for example, can give you an image file easily capable of a 16x10 printout on an inkjet or other printer.

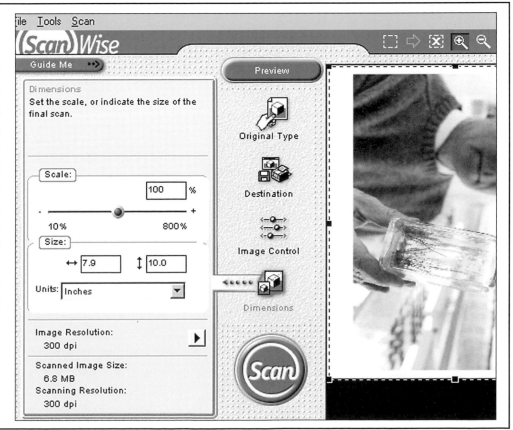

## 59.

The key to getting a good scan from a print is to start with a good print. This is really important, as you cannot scan detail that is not in the print. Going to a cut-rate processor for your film processing and printing can be a false economy, as you'll spend way too much time fixing a "good" scan of a poor print.

## 60.

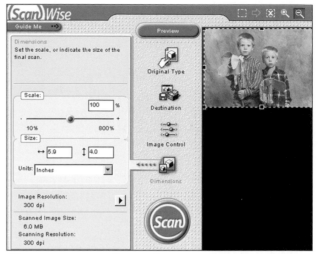

You can actually enlarge a smaller photo quite a bit in the scan if the original is sharp and has good tonal detail from dark to light. Just scan at a higher resolution, such as 600 or 1200 dpi if your scanner offers this.

## 61.

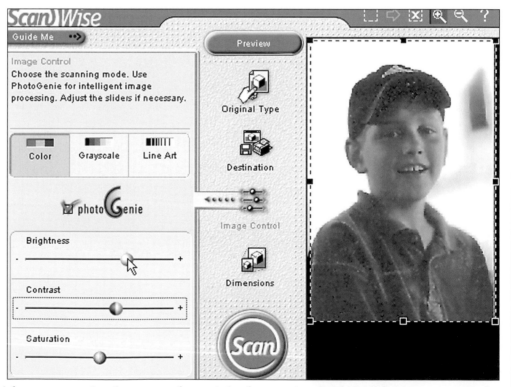

If you have to deal with a poor print because the original negative had problems, you may be able to fix some of those problems later in the computer. However, go for the best scan you can get at this scanning stage by adjusting the preview to get the best looking image you can and the most detail you can find.

## 62.

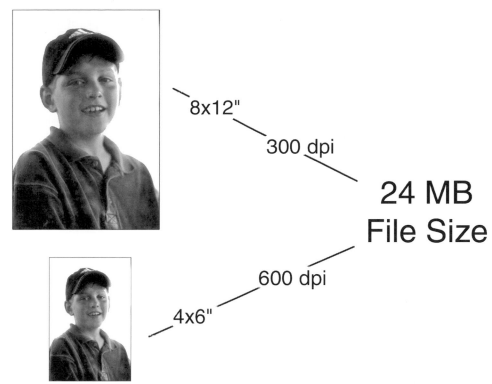

8x12"

300 dpi

24 MB
File Size

600 dpi

4x6"

To get the appropriate file sizes for the desired output, you will need to change the scanning resolution (dpi—dots per inch). An 8x10 scanned at 300 dpi will give a file of about 20 MB and so will a 4x6 scanned at 600 dpi. Use the higher dpi settings only when scanning small images that you will need to enlarge later.

## 63.

# 600x1200
# Resolution
# With enhanced
# resolution
# to 9600 dpi

Many manufacturers of flatbed scanners will give outrageously high resolution numbers beyond the optical capabilities of the scanner (e.g., 600 dpi "with up to 4800 dpi resolution"). That high number is usually an interpolated number, meaning the scanner didn't actually see data at that level, so it tried to figure out or "interpolate" what might be there. Another way of saying interpolation, though, is "guess." Don't use it.

## 64.

Prepare your flatbed scanner by cleaning the glass surface where the photo will go. Any dirt or other debris on this will show up on the scan. Use an antistatic brush, compressed air and a special microfiber cleaning cloth as needed. Keep your scanner bed as clean as you can to minimize problems with specks on the scan.

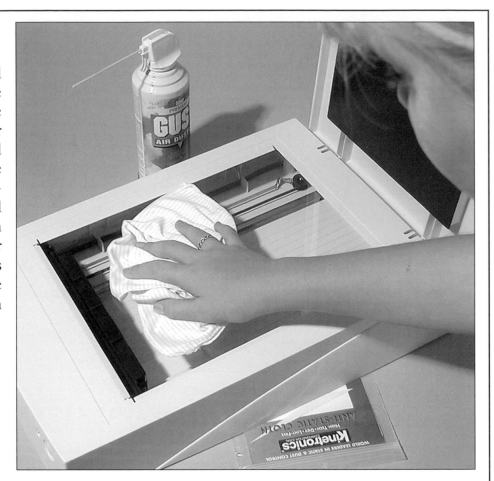

## 65.

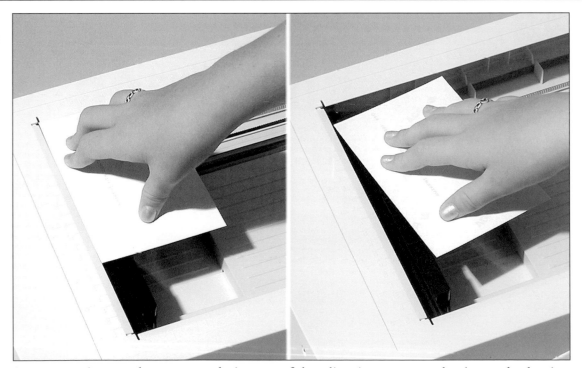

Set your print on the scanner, being careful to line it up correctly. A crooked print will mean added work for you once it is in the computer. However, you can correct a photo with a slanted horizon or other out-of-alignment lines by actually scanning the print "crooked." You simply line up the print based on a key line in the image rather than the print edges.

## 66.

Set your scanner driver for the appropriate resolution, then do a preview scan. At this point, you'll be doing your normal adjustments to get a good scan. On a flatbed, you have to tell the scanner what area to scan. Move the edges of your scan area into your photograph until you get only what you need. If you scan only what you need, the file size is more manageable, making the processing of the scan faster and later work on the image easier, as well.

## 67.

Check to see where the scanner is putting your image. Is it going to the hard drive, to your image processing software, or both? If you are sending the image to the hard drive, be sure to note where it goes (what directory or folder) and chose a name that can be easily recognized when you go looking for the scan (such as "orange rose close-up" compared to "flower003"—sometimes it is easier to abbreviate the words so they take up less space in the folder window, such as "orng-rose-cu").

## 68.

Tell the scanner to start scanning, then check the final scan at full size on your screen. It may look different than the small preview. Throw it out if you are not satisfied, do a new preview, make some new adjustments and scan again.

## 69.

Scanning from a slide has a great advantage of giving you an original to match. While you will often want to adjust your final image to something different than the original, having the slide with its colors, brightness and contrast set from the original exposure gives you a convenient starting point based on how your camera and film originally saw the scene.

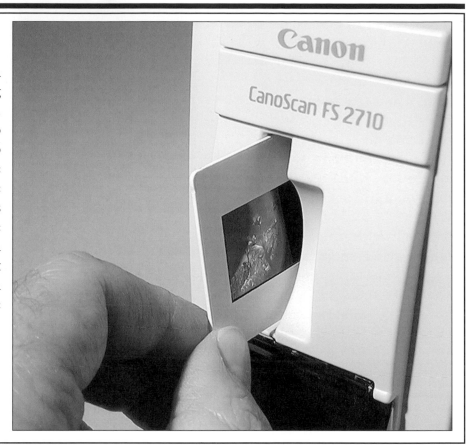

## 70.

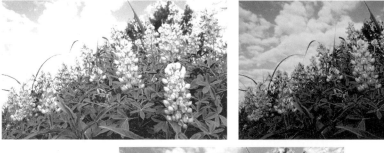

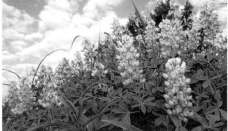

## Bracketing Slide Exposure

Slides start with a narrower tonal range and exposure tolerance than negatives, so you do need to pay close attention to exposure when you shoot the original scene. A badly exposed slide is murder to try to scan well. Bracketing exposure can be an important technique to ensure that you get the best exposure for scanning (which can be different than for other purposes).

# 71.

Beware of too dark a slide. Scanners, especially less expensive ones, can pick up noise (usually a pattern that is not in the image) in black and very dark areas. This is not a major problem with brighter images, but very dark slides can be a concern. Even if the scene is naturally dark, you may find it better to have a brighter slide for scanning that you can darken later in the computer .

Scanner noise in dark areas -- enlarged and enhanced

# 72.

With a film scanner, you must clean your slide before putting it in the scanner. This is really important, as dust shows up as big defects in the scan, which will make a lot of extra work for you later. Use an antistatic brush and compressed air.

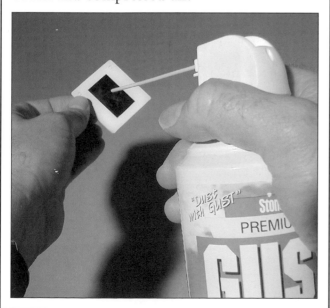

# 73.

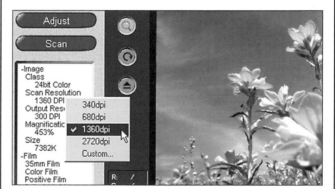

Set your scanner driver for the appropriate resolution, then do a preview scan. The resolution of film scanners is very high compared to most flatbed scanners, starting at 2400 dpi and going up to 4000. This is needed because a slide or negative is so small and needs to be enlarged a lot for it to look good. Enlarging the image spreads out those dots so they aren't as dense as when scanned. This is why most flatbeds do poorly with slides or negatives—even if they have a film adapter.

# 74.

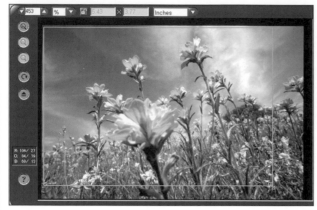

Now make your normal adjustments to get a good scan. The preview will show you the whole slide, so you can decide if you want to do any cropping at this point. Move the cropping lines into your photograph until you capture only what you need.

# 75.

Most film scanners have more controls than the common, low-priced flatbeds. Use these color, brightness and special tools as needed to get the best looking photo on your screen before scanning. Match the slide as desired, or creatively change the image as desired, but it is always better to make these basic adjustments before scanning.

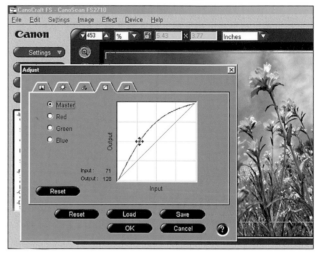

# 76.

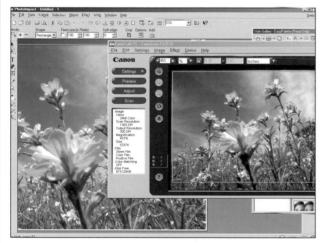

Just as with a flatbed, check to see where the scanner is putting your image. If it goes directly to the hard drive, be sure to note where it goes (what directory or folder) and chose a name that can be easily recognized when you go looking for the scan. Also, use a file name that will help you more easily find your image later.

# 77.

Tell the scanner to start scanning. Just as with the flatbed, check the final scan at full size on your screen. It may look different than the small preview. If you are not satisfied, do a new preview, make adjustments and scan again.

## 78.

Scanning a negative directly offers one of the highest quality, most adaptable image files possible. Film scanners are sometimes called slide scanners, but every film scanner scans both slides and negatives.

## 79.

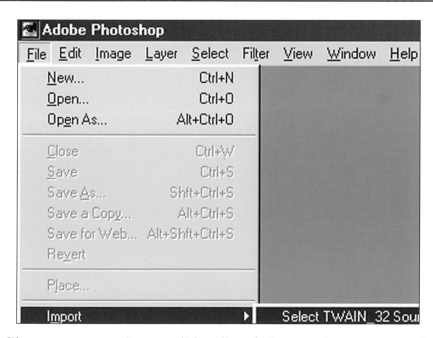

Most photographers like to scan negatives or slides directly into an image processing program. You'll see several ways of accessing your scanner through the program. Import>TWAIN is quite common, and simply describes a way that many high-end scanners have of communicating with the image processing software.

## 80.

Negatives capture the world with a wider tonal range than slides do. Both offer the potential for excellent images, but the negative's wider tonal range gives you more possibilities with the scan. You have more control over brightness/contrast and available colors. You will actually find more detail in the negative than you will get from a standard print from your local lab.

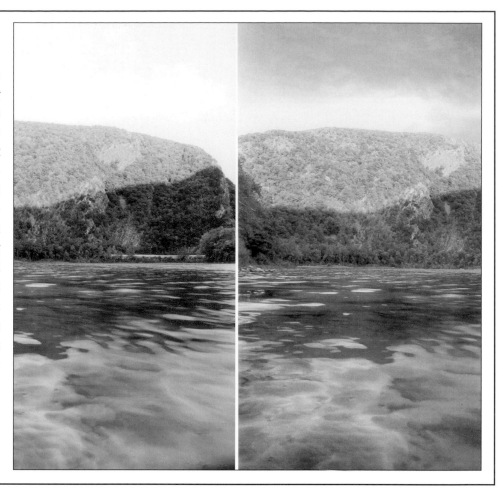

## 81.

Negatives can be hard to understand if you are not used to looking at them directly. Try to find a processor who gives you prints with numbers on the back so you can find the exact negative you want. This way you can use your prints as proofs to help you decide what images to use and to start thinking about adjustments needed.

## 82.

If you have a choice of exposures of your negatives from the same scene, choose the "densest" negative. This is the one with the most dark areas and least clear parts of the image. Clear parts have no detail and give you nothing to work with. Avoid really dense negatives, too, ones that are significantly darker than most on the roll.

# 83.

Remember to clean your negative before putting it in the scanner. Keeping the negative clean now will save a lot of work later. Use an antistatic brush and compressed air.

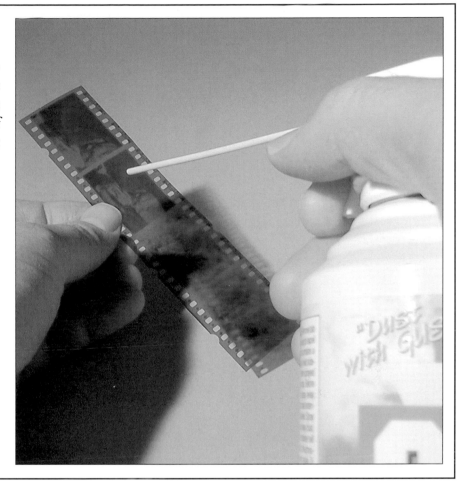

# 84.

Be careful as you handle the negative and put it into the negative holder for the scanner (or if your scanner doesn't use such a holder, be careful how you handle the negative as you feed it into the scanner). Some people like to use white gloves (available at camera stores) so they can easily handle the negative in the holder with no danger of scratching it or putting fingerprints on it.

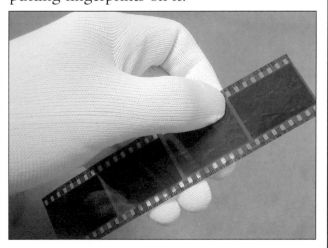

# 85.

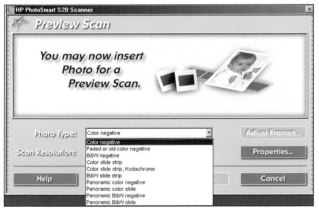

Set your scanner driver for the appropriate resolution and for negative. Color negatives look really screwy if the driver is set wrong.

# 86.

Do the preview scan. Since the preview will show you the whole image now as a positive, this is a chance to confirm that this really is the image you want to scan. You can also do some cropping at this point by moving the cropping lines into your photograph until you capture only what you need.

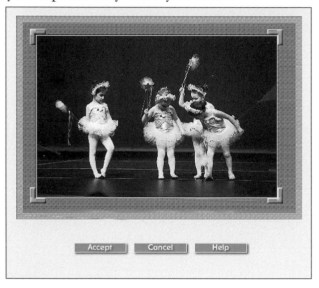

# 87.

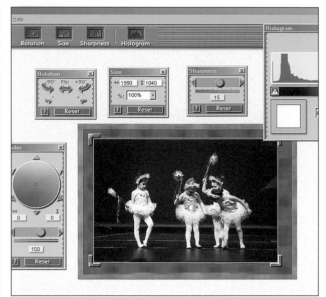

Remember that most film scanners have more controls than the common, low-priced flatbeds. With the added detail possible from a negative, use these controls to get the most detail, tones and color on your screen before making the final scan.

# 88.

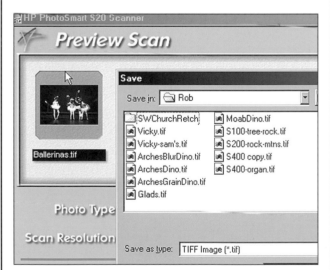

Just as with a flatbed, check to see where the scanner is putting your image. If it goes directly to the hard drive, be sure to note where it goes (what directory or folder) and chose a name that can be easily recognized when you go looking for the scan. Also, use a file name that will help you more easily find your image later.

# 89.

Tell the scanner to start scanning. Just as with prints and slides, check the final scan at full size on your screen. If you are not satisfied, do a new preview, make adjustments and scan again.

# 90.

Most people don't real-ize that a flatbed scan-ner can also be used to scan three-dimensional objects—anything from rocks, to jewelry, to flowers. As long as it fits on the scanner glass, any object can be scanned to make a pho-tograph. Used in this way, your scanner actu-ally becomes equivalent to a very high-quality digital camera that even includes a light source!

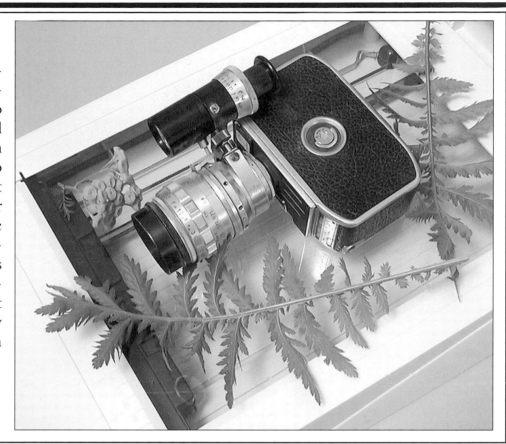

# 91.

You will want to be careful of objects with hard, sharp edges that might scratch the scan-ner glass. Also beware of objects that might leave a residue that could harm the glass.

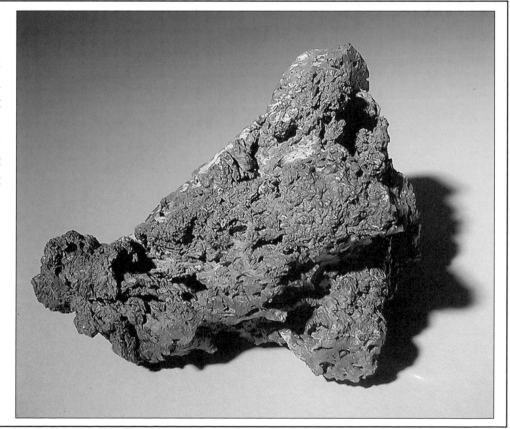

# 92.

To scan the object, clean the glass surface just as if you were going to scan a regular photograph.

# 93.

Carefully place the object on the glass, with the surface you want to see in the scan facing down. The scanner won't have a lot of "depth of field," or sharpness from the glass upward, but you may be surprised how much you do get.

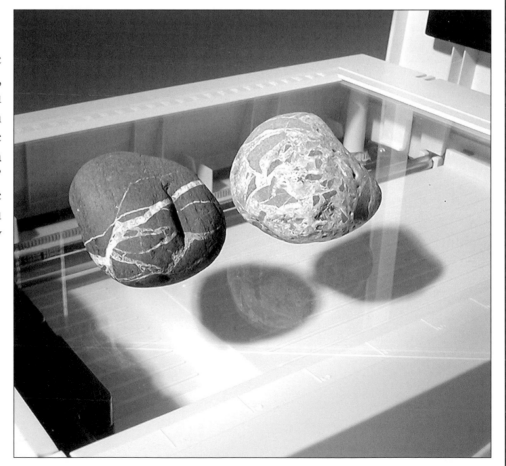

# 94.

It often helps to put a piece of paper or fabric of contrasting brightness or complementary color over the object so that you get a background that scans in, too.

# 95.

If you know you want to cut the object out of the scan later and put it onto some special background, use a bright color such as red, green or blue behind it. Choose a color that is not in the object. This makes the background very easy to select and isolate in image processing software.

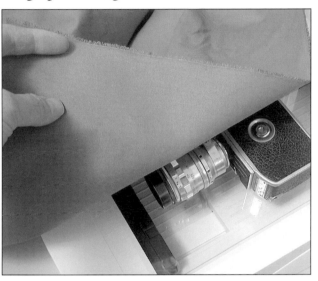

# 96.

Multiple objects, like a grouping of flowers and leaves, can be scanned, allowing you to create an interesting composition right on your flatbed's glass. Keep in mind that you are building this composition from front to back. Lay your front pieces on the glass first, so that they are on the bottom of the stack of objects, to be seen first by the sensor.

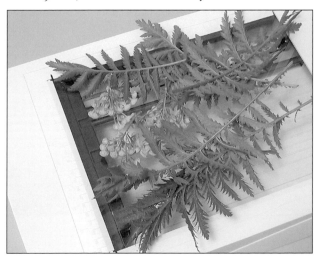

# 97.

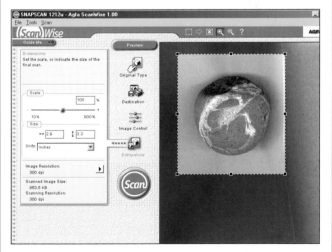

You can actually enlarge a small object quite a bit in the scan. Just scan at a higher resolution, such as 600 or even 1200 dpi if your scanner offers this.

# 98.

A preview scan for your object is like a test exposure. Now you can see what the object looks like as an image. Is it bright enough or should it be darker because bright areas are getting washed out? How about color? Make the adjustments needed.

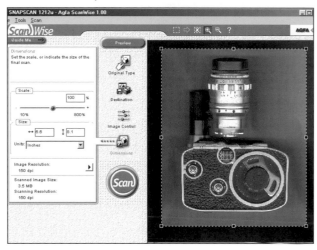

# 99.

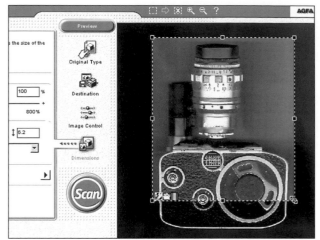

Remember that the scanner can't do an auto-select of the area (as some scanners do) because you don't have a photograph yet. So you have to tell the scanner what area to scan. Move the edges of your scan area around your object until you get the composition you need.

# 100.

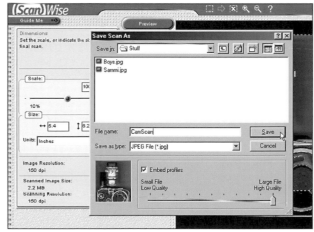

Once again, be sure you know where the scanner is putting your image. Is it going to the hard drive, to your image processing software, or both?

# 101.

Now you can "take the picture" by starting the scan. You'll want to check what the object looks like now as a photograph at full size on your screen. Throw it out if you are not satisfied, do a new test picture, make some additional adjustments and scan again.

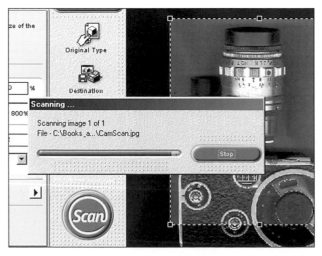

## 102.

CD-based images, whether a Photo or Picture CD (the actual brand names), are actually professional scans. They give photographers without a scanner the ability to bring images into the computer. They also offer all photographers, whether you have a scanner or not, the chance to gain some very large scans that might not be possible with a standard scanner.

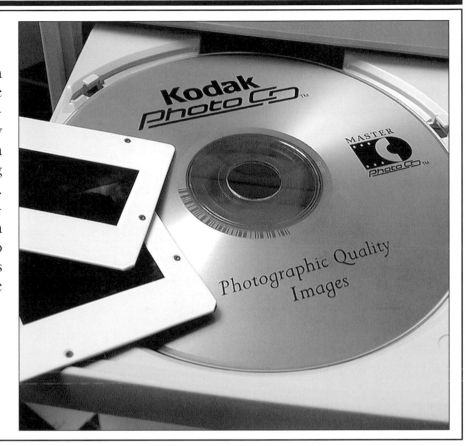

## 103.

Photo CDs can be done when you have your film processed or later. You can add slides or negatives to an existing Photo CD until it is filled up (100 images). The standard Photo CD is only for 35mm and APS.

5210 1612 1121

# 104.

A Photo CD includes five resolutions of every image. They range from a basic thumbnail of only 64 x 96 pixels (not very useful) to the largest scan of 2048x3072 pixels, a very useable file that easily can provide enough data for an excellent 8x10 print.

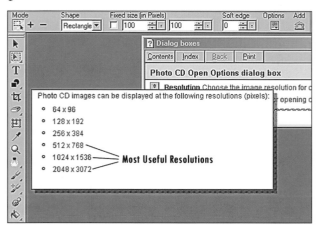

# 105.

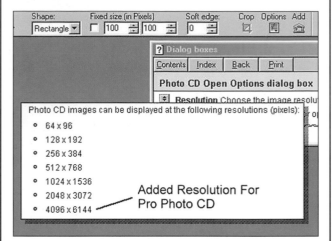

The Pro Photo CD adds another resolution, a very big 4096x6144 pixels, and can be used with both 35mm and larger format images. A Photo CD scan is a craft, not a science, so if you get poor results from your local supplier, try again at another lab or service bureau.

# 106.

The Picture CD is a recent arrival on the scene. It is designed to be appealing to the general consumer by being easy to use and convenient to buy (you order it when you have your film processed). It may not give enough resolution for the serious photographer (it is usually only 1536x1024 pixels in size, although a few labs do offer 2048x 3072).

## 107.

It's important to remember that creating a Photo or Picture CD from professional scans is a craft, not a science, so carefully evaluate the work you get from any lab or service bureau. If it doesn't work for you, try another lab.

## 108.

Even the pro-scans from a Photo CD usually need some work. The Photo CD operator can't see into your mind and figure out what you had in mind for the image. Usually, you'll need to do some sharpening, brightness/contrast adjustment and color tweaking.

## 109.

When you scan an image in any way, you will create an image file. There are a number of important image file formats to consider using. All of these can be translated to each other as well as additional formats in your image processing software (under Save As or Export).

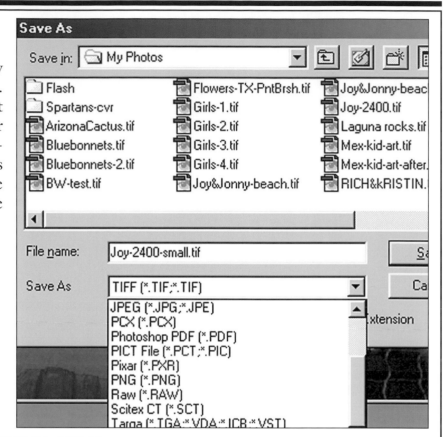

## 110.

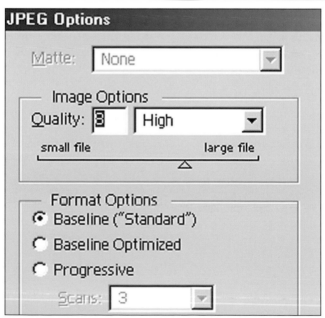

JPEG stands for Joint Photographic Experts Group (it will have a file extension of .jpg). This is a compression format used to reduce the size of photo files without changing the image and is useful when you need to keep file sizes small. JPEG, though, throws out data as it compresses an image (which is why it is called a "lossy" format). At high quality, low compression levels, the image looks fine. But at high compression, low quality, the image will really begin to suffer.

# 111.

Use JPEG sparingly. If your scanner saves an image as a JPEG file and you open it in your software, resave it as a TIFF (or in the native format of the software). Don't repeatedly open a JPEG image, work on it, then save it, as the losses due to the compression really add up. Use it to conserve disk space when you are done working on an image, for images that will be sent via e-mail, or when putting an image on floppy disk (where space is really restricted).

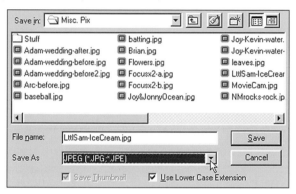

# 112.

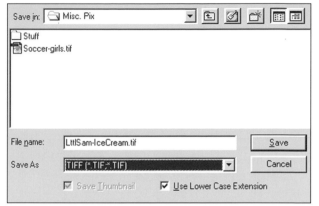

TIFF or Tagged Image File Format is one of the most useful imaging formats as it is recognized by nearly every photo processing and design software program (it will have a file extension of .tif). It is even transported easily across platforms (Mac and Windows). The basic form of TIFF has no major compression algorithms, so it stays lossless.

# 113.

BMP or Bitmapped is a common file format for Windows (it will have a file extension of .bmp). It is similar to TIFF, but is not as universal and is not readily used cross-platform. However, many scanners scan to a BMP file.

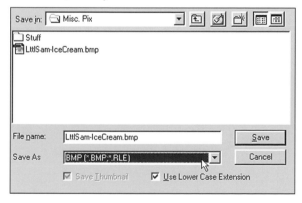

# 114.

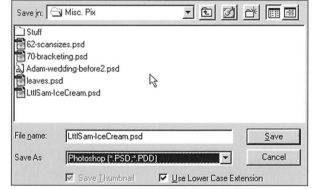

Every image processing program has a unique file format associated with it. This is the format internal to the program and is referred to as the native format (file extensions vary). When you scan into your image processing program, the photo is translated into this native format. Native formats only work with their unique program, but they are often the only way to work with an image within that software and keep certain image editing options open at the same time.

# basic adjusments
# to the scan

## 115.

| Name | Size | Type |
| --- | --- | --- |
| AnzaBorego2.tif | 19,601KB | TIF File |
| ArchesGrainDino.jpg | 4,431KB | JPG File |
| bb-card.TIF | 8,964KB | TIF File |
| grasshopper2.tif | 7,477KB | TIF File |
| Kids-pigeons2.TIF | 10,169KB | TIF File |
| Metro.tif | 9,209KB | TIF File |
| Mountains.tif | 8,049KB | TIF File |
| PowWow.tif | 21,228KB | TIF File |
| Ron-Pam.tif | 18,851KB | TIF File |
| VasquezRock.tif | 4,397KB | TIF File |
| Arc-d-T.tif | 4,757KB | TIF File |

One way of telling how much information a scan has is to look at the file size. This is independent of the dpi or inch measurements of an uncompressed image (.tif or .bmp). You can consider a 4-5 MB file good for a high-quality 4x6 inkjet print, a 8-10 MB file for 5x7, and a 18-20 MB file for 8x10.

## 116.

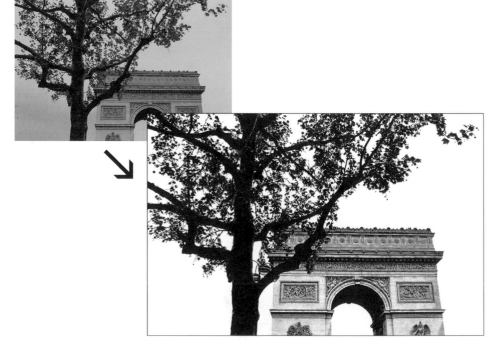

Once you've completed the basic scan, your work has just begun. Scanning is much more than running a photo through a scanner. In addition, you will definitely find a satisfaction from getting the image just right, just as you want it.

# 117.

The first thing you need to do is evaluate the photo. You've already done a simple check when you decided if the scan was good enough to keep. Now you're going to look over the image to find adjustments that need to be made. You will be making adjustments to even the best scan, as the data in a scan is rarely complete until you do this.

# 118.

Check the overall brightness/darkness. Adjust the image appropriately so that highlights are bright, but not washed out. The picture may look a little grey at this point.

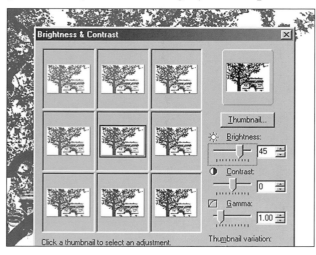

# 119.

Modify the contrast to get rid of the greyness. The deepest shadows should be black. It is very important to have good strong blacks in the image. You may have to go back and forth between brightness/darkness and contrast to get this right.

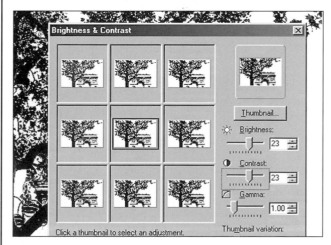

# 120.

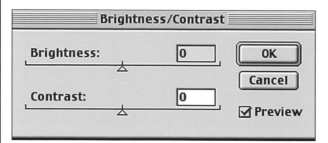

Brightness and contrast can be adjusted with several tools. Most photo processing programs have at least a couple of sliders that you can move. The brightness/darkness slider will generally have the lighter settings to the right, darker to the left. The contrast slider will keep higher contrast to the right, lower to the left.

# 121.

Some programs have what are called "levels." This adjustment uses a chart of the tonal values in the image (dark to left, bright to right) and controls that allow you to adjust the blacks, mid-tones and whites separately. This is a great tool for correcting a scan. If the black or white sides look weak (have little data according to the histogram), move the black and white scanners into the area where the data curves start.

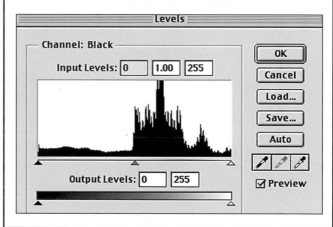

# 122.

Another adjustment control is curves. This uses a graph with *x+y* coordinates. You can move the bottom endpoint to affect black, the top to affect white and the middle to change brightness. In the RGB work space (the normal color space for computers, which you will always start with), as the curve goes up, brightness does the same. Steeper curves will increase contrast.

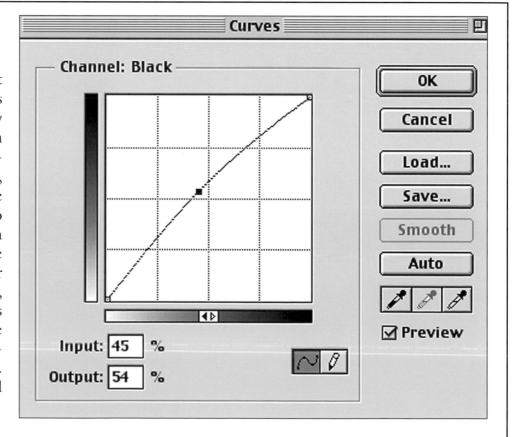

**123.**

Color will usually need some quick tweaking, although this will vary considerably. Some scans will have color you love from the start. But if you were shooting under less than ideal conditions, you may have a color cast to correct.

**124.**

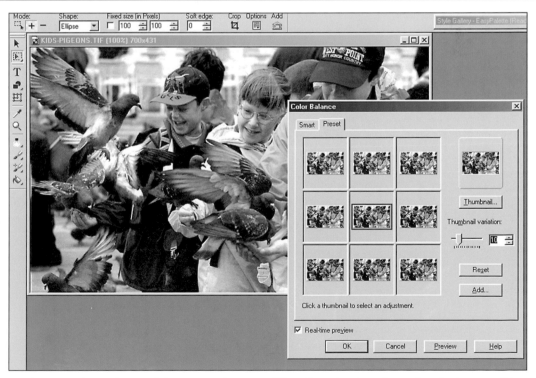

Color can be adjusted in several ways. The first is simple color balance. You decide what color cast needs to come out, and what one needs to be enhanced. You can add a nice warming filter effect by adding yellow and red in similar quantities.

# 125.

You can also adjust color in the saturation and hue section. Sometimes the scan just doesn't capture the color saturation you had seen at the shoot, and turning up the saturation setting can help. Hue changes give pretty dramatic color shifts, but when used sparingly, they can be a good way of dealing with color, as well.

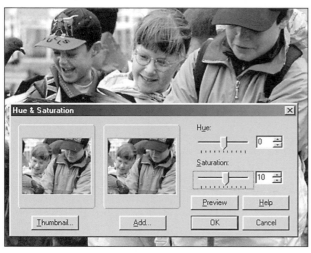

# 126.

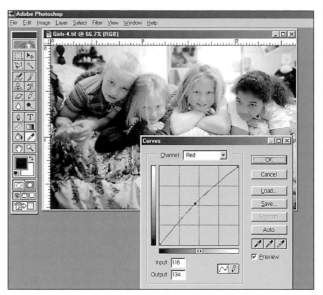

The third way to adjust color is not available from all programs. You simply look at the color channels individually (R, G and B) and then tweak the levels or curves for one color at a time.

# 127.

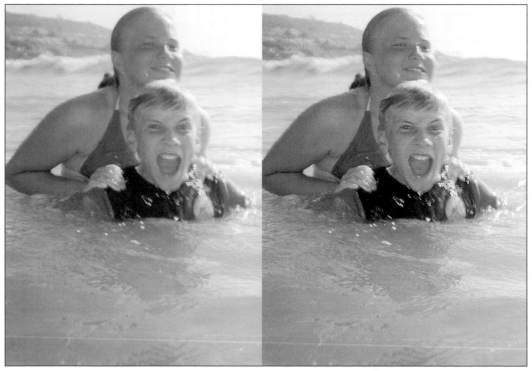

All scans need sharpening. This is not a defect of the scanner, nor is it a fix of an unsharp original. You can't make an unsharp original sharp. This simply reflects the way that scanners interact with the photo, which makes it necessary to do some sharpening to bring out the sharpness of the original.

# 128.

Most image processing software has a sharpening tool that will work. If you need to do heavy sharpening, it is usually better to apply smaller amounts more than once than a big change at one click of the mouse.

# 129.

Be careful of oversharpening. You don't want the photo looking a little weird—with overly strong edges on the picture elements (unless you are after a certain effect).

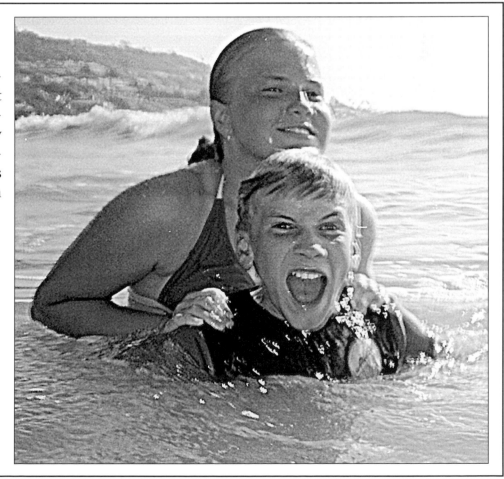

# 130.

Unsharp mask is a sharpening tool (in spite of the name) on some programs. If yours has it, use it, as it offers much more flexibility and control over your sharpening.

# 131.

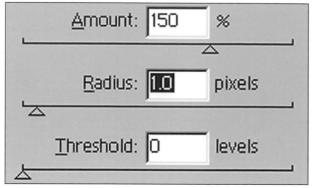

Unsharp mask has three settings: amount, radius and threshold. Experiment for the best results. Start by setting the radius to 1 for average sized photos, to 2 for big image files (15-20 MB and higher). Set the amount to somewhere in the middle to slightly above the middle range. Grain can get overemphasized from sharpening. Higher threshold settings can minimize that—try something in the 5-15 range.

# 132.

In spite of careful cleaning of the scanner glass or a negative or slide, dust, scratches and other little defects do appear on a scan. While some software programs have dust and scratches settings, the use of such overall adjustments tend to soften the sharpness and detail of the photo too much.

# 133.

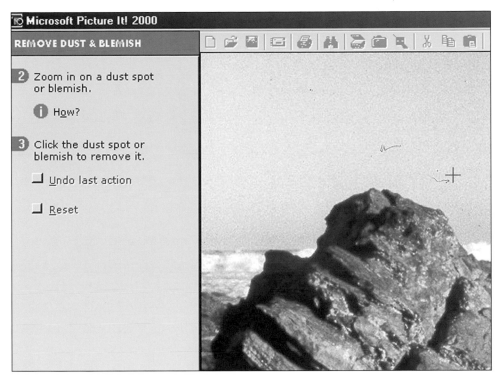

A few low-priced programs, surprisingly, have quite good dust and scratch tools where a single click on the offending speck will remove it.

# 134.

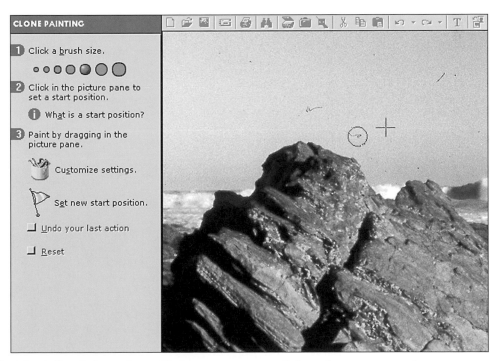

The cloning tool is ideal for fixing dust. Enlarge an area of the photo to work on, so you can see the dust more clearly. Then set your cloning tool so it picks up a color or tone that can go over the dust speck so that it disappears. Use as large a cloning brush size as you can without causing other problems and choose a soft edge for the cloning tool (or brush).

## 135.

Scratches can be bad news, so always try to handle film carefully. Still, some dirt in the camera or at the processor can give you scratches that need to be removed. Again, some software programs have dust and scratches settings, but these overall adjustments tend to soften the sharpness and detail of the photo too much.

## 136.

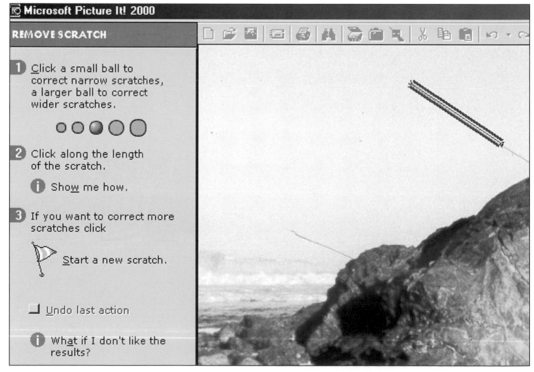

Scratches are fixed in a similar way. Some programs actually have a scratch removal tool that you can use to paint over the scratch and let the software fill in the needed data. The latter works great in skies and other detailless areas.

## 137.

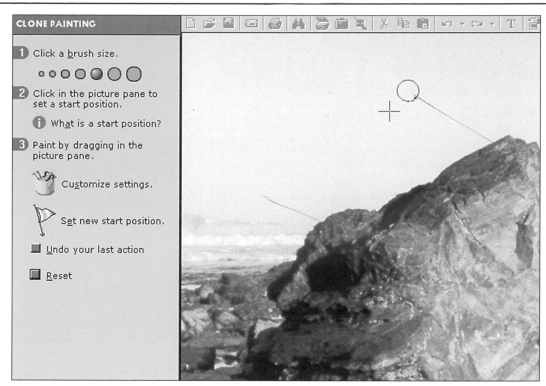

You can also clone out a scratch manually. Set your cloning tool size to a little bigger than the width of the scratch, and use a soft edge. Then pick up pieces of the image from both sides of the scratch and clone them into the scratch a little at a time.

## 138.

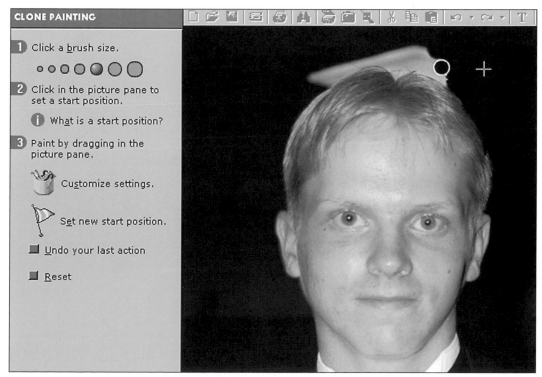

Sometimes you'll find something really distracting in your scanned photo, such as someone's foot in a corner of the composition or a piece of the background growing out of your subject's head. If it isn't too big in size, cloning is also a good way of fixing the problem.

## 139.

Once you see the image on your computer monitor, you may find it has distracting "hot spots" or over-bright areas. Our eyes naturally look at the brighter parts of a photo first, so you may find some areas that are brighter than they need to be and definitely need toning down.

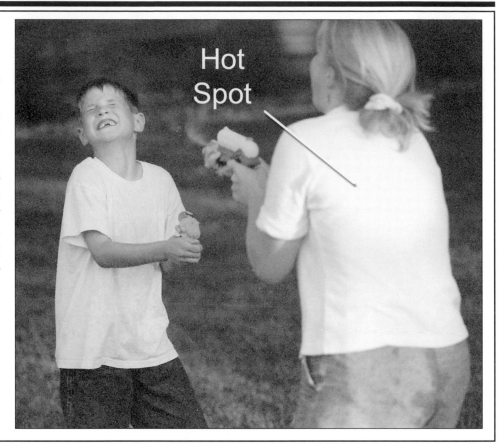

## 140.

In darkroom terms, you would "burn-in" too-bright areas to make them fit the rest of the image better. In the computer, you can do several things. One is to use a burning tool that allows you to carefully darken a small area. Some programs accomplish the same thing with a painting tool that literally allows you to paint the darkness on. Whichever you use, do your burning in small steps so you don't overdo it.

# 141.

Without either of these tools, you can try a paint brush. Grab a color close to the darker colors around your problem and lightly brush in a tone. If your brush has a transparency or density setting, change this to allow the original to show through the painting.

# 142.

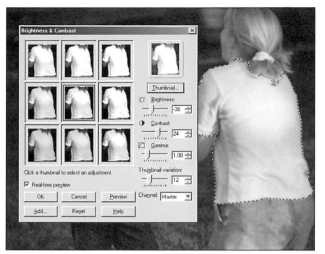

Without a burning tool, you can also select the area that includes the problem, feather the edge, then darken the image in these selected area only.

# 143.

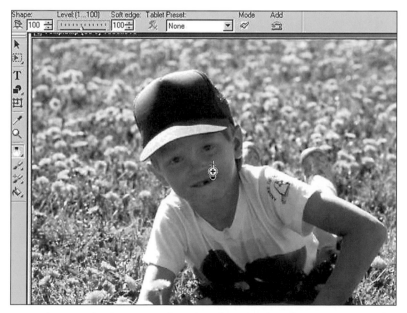

When the problem area is too dark, say a face in the shade, then you need to "dodge" the area (another old darkroom term). There are dodging tools available in a number of image processing programs, as well as painting tools that allow you to paint a brighter image. Just like with the "burning" tools, try to dodge in steps by keeping the settings low.

# 144.

Just as with burning in, you can dodge by selecting around the problem and lightening that area alone.

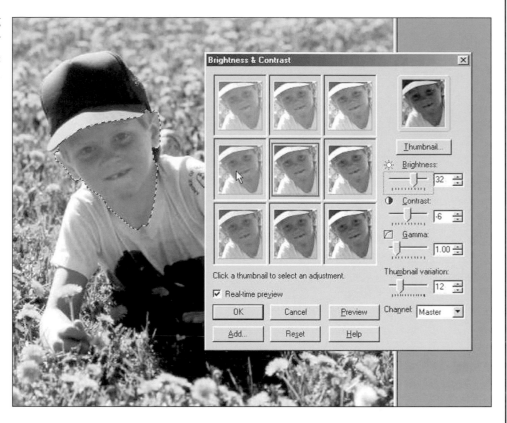

# 145.

A caution about both dodging and burning: if done too casually, the edges of the area can get too bright or two dark, and actually outline your problem (something to avoid).

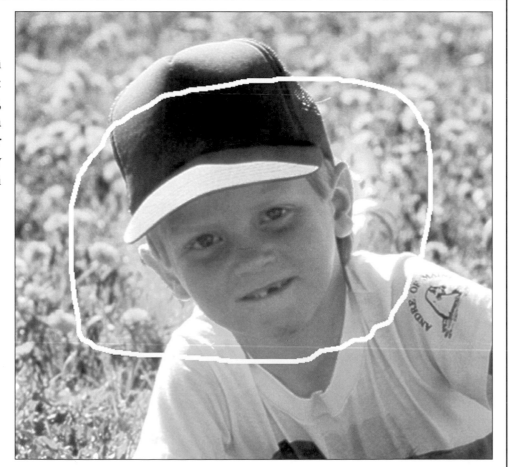

## 146.

To really get the most from your scanned photos, you need to be able to understand and use selections. Selections are simply parts of an image that you carefully select to isolate them from the rest of the picture. This allows you to adjust one part of a photo without affecting anything else.

## 147.

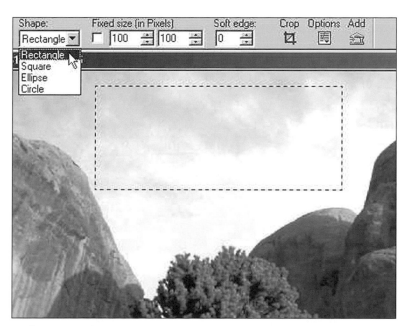

Most image processing software will give you several options for selections. Specific shapes can be used to select an area that is clearly defined and fits the shape.

# 148.

Freehand selection tools (sometimes called a lasso tool) allow you to go around any object, no matter what its shape—a very useful feature. Magnify your work area so you can better see the edges of the object you are selecting.

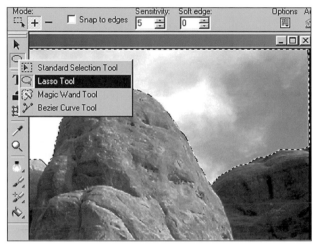

# 149.

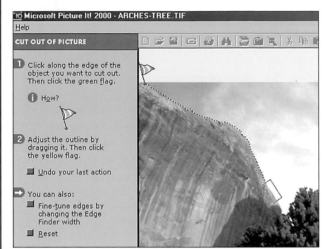

Many programs now offer "magnetic" freehand tools that even help find the edges of areas for you. You don't have to precisely hit the edge—the tool does the precision work for you as long as the edge is distinct.

# 150.

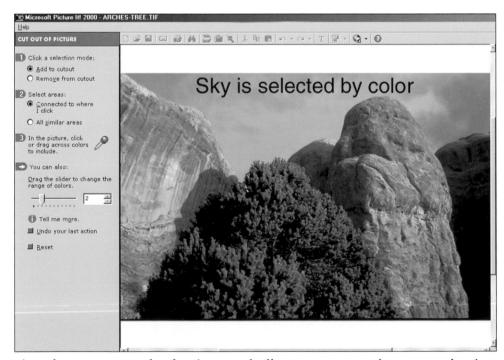

Another automated selection tool allows you to make your selection based on similarity of tone or color. Sometimes called a "magic wand," this is great for isolating a sky or a plain background.

## 151.

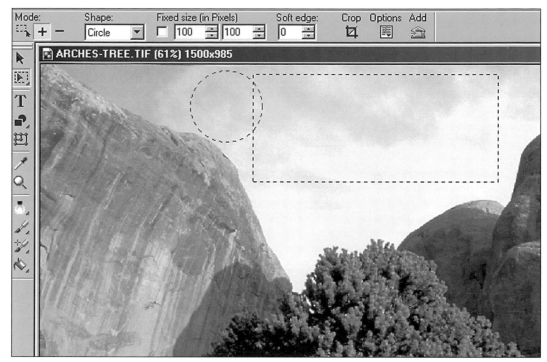

Once you make the initial selection, you may need to adjust its edges. You can always add to your selected area. This lets you use a shape tool, for example, to quickly select a big area, like most of a sky, then use a freehand tool to add to the selection to refine it.

## 152.

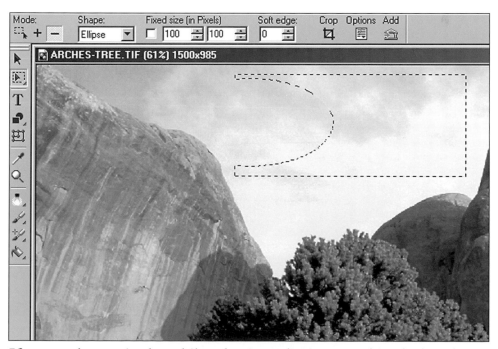

If you make a mistake while selecting, that's not a big deal and you don't have to start over. You can also subtract from a selection. Subtracting again lets you fine-tune your first selection area.

# 153.

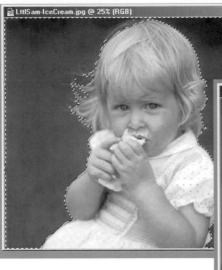

Certain parts of a photo are easier to select than others, such as a plain background, but that photo element (the background) is not the one you need to isolate, such as a person against the background. In this case, it may be easier to first select the easy part around the subject, then invert the selection. This gets you to the important selection without the work of carefully finding the edge of the more varied object.

# 154.

Most of the time you will want to soften (or feather or smooth) the edges of your selection. This helps make changes to the selected area better blend with the rest of the photo. For small selections or selections next to very contrasty changes, you'll want a smaller feather of just a few pixels. For larger selections and areas that are against less contrast, you can make your feather quite a bit larger.

# 155.

Now that you have your selected area, what can you do with it? You can change the brightness/contrast or color of it without changing anything else.

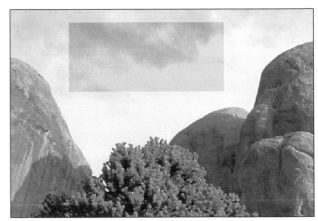

**156.**

With a selection active, you can change the focus of one area next to another. Make your subject stand out better against a blurred background.

**157.**

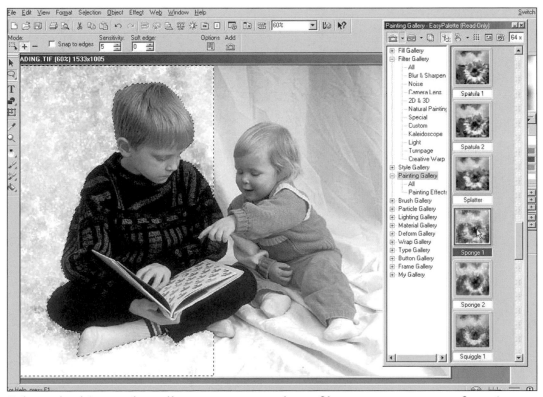

Selected objects also allow you to apply a filter to one part of an image without affecting any other part. You can make the environment around your subject very abstract and arty, for example.

## 158.

Compositing is a way of cutting parts of one photo out and applying them to another to create a new image. With a scanner, this becomes very convenient and easy, since you can scan in photos as you need them. It also makes you freer and perhaps more creative, because you can use anything available that can be scanned as compared to being limited by images already in your computer or on disk.

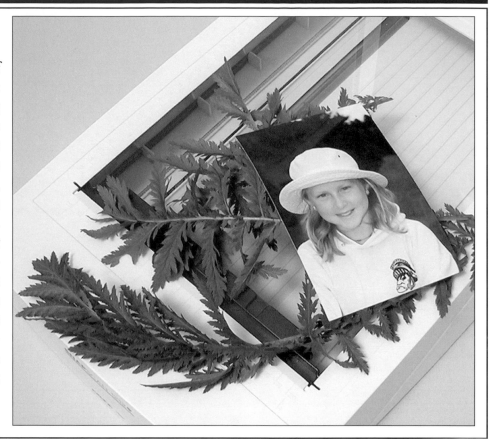

## 159.

Compositing can be a great way of dealing with the limitations of photography. You may come across a scene that has too much contrast for film, in that your eyes can see detail in the shadows and sun, but you know the film can either show the shadows or the highlights, but not both.

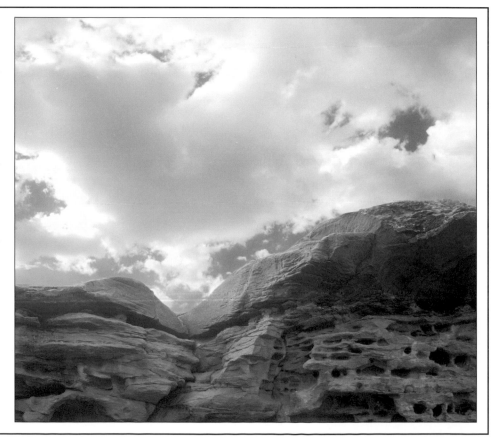

# 160.

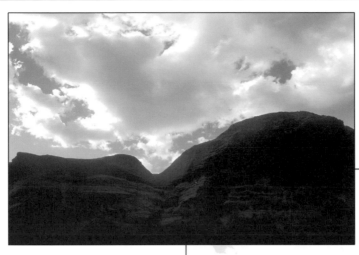

**Exposed for sky**

**Exposed for rocks**

By taking two photos, one exposed for the shadows and one for the bright areas, you can scan both and composite the bright parts of one photo with the well-exposed shadows of the other to get a more accurate image (*see* frame159).

# 161.

Another use of this compositing technique can increase your sharpness in a photo. You start with two photos, one having the focus on closer objects, the other with focus on more distant things, then scan them both.

# 162.

The two images (sharp foreground and sharp background) can then be combined so that the sharp areas of each image are kept, giving you a greater depth of field not otherwise possible.

# 163.

Compositing for fun or fantasy is another good use of the technique and your scanner. The great advantage of having your own scanner nearby is that you can scan the exact pieces you need for your image as you go. For example, you want to add wings to a little "fairy" and are not sure which choice is best for wings. You can very quickly scan the wing photos in to try them all out.

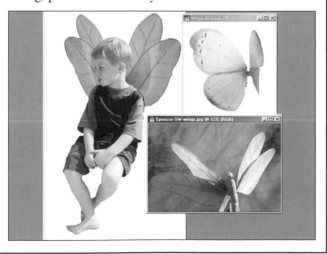

# 164.

Compositing images for illustrative or education purposes is another excellent use of your scanner. You could, for example, add a bold flower to a scene to help someone better understand ecology.

## 165.

A popular way of adding images together is the montage. This has long been a great way of expressing something about a subject that could not be done in a single image. Now you can combine these images in the computer to make a finished image that is complete and whole for printout and then use it as a photo album.

## 166.

A great combination of images can come from scanning objects (see Frames 90-101) and using them in a collage or as a background for another photo. For example, you can scan some interesting leaves directly to use as a frame for a portrait.

## 167.

When considering composites, there are several things to keep in mind. First, plan before you scan. Get the images or objects ready and place them near at hand so you aren't searching for them as you scan.

# 168.

Photograph image elements so they will go together better in a composite. Shoot each piece of the planned composite with similar lighting, contrast, color, tone and sharpness.

# 169.

Once you've scanned your picture elements, carefully select the parts you need to use in the composite, then copy and paste them into the final image. Adjust the pieces (if you have separate layers in your software, this can make the adjustments easier) so the edges blend, so they have similar light and dark qualities, so colors and sharpness look like they belong, and then add "grain" (noise) to areas that seem to be too smooth for a photograph.

## 170.

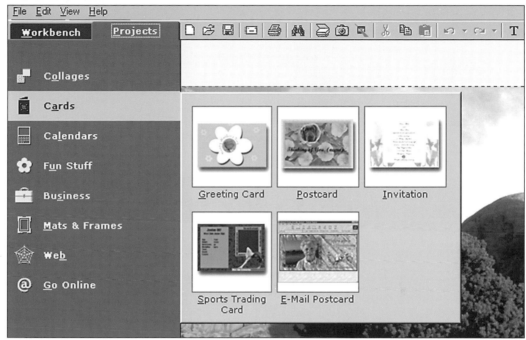

Scanning lets you bring all of those photos out of the back closet and share them with others. Scanners can even scan directly into software programs that let you use your photos in special ways, such as in a greeting card or a newsletter. The scanner helps you to put your photos to work.

## 171.

Put your images into your own greeting cards. You can personalize both the photo and the message.

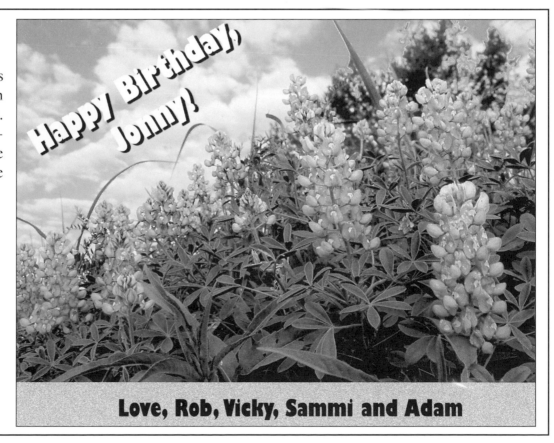

# 172.

Make a business card or even a personal card. Your photo will make it stand out.

# 173.

Design flyers and brochures for your business or community organization.

# 174.

Make a calendar featuring your photography.

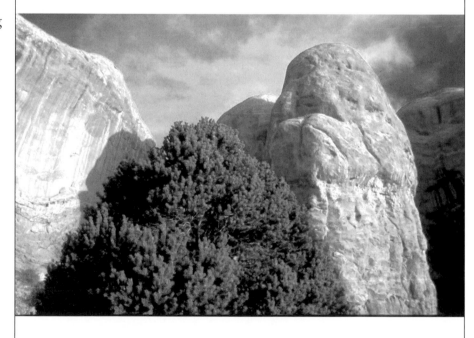

## 175.

# Fall Family Update

October 2001

## Soccer Season In Full Swing

Sammi's having lots of fun this fall with another great soccer season. She's playing goalie again for the first half, then halfback in the second. She really likes playing goalie, or "keeper", as the soccer jargon goes.

The team is now 5 wins and 2 losses, although Sammi has shut out the other teams while she has been goalie. Some pretty exciting games!

## Wooden Bat League Fun For Adam

Create a newsletter to show off your family, kids group or church.

## 176.

Make a photo book of the people in your organzation.

# Varsity

**Chris -- SS**

**Akira -- 1st**

**Kevin -- student mgr.**

**Eric -- 3B**

**Mike -- Pitcher**

# 177.

Add photos to your letters for a personal and high-impact effect.

## A Letter From Rob

**Dear Judy --**

**I just got back from our trip to the Southwest. I loved the rocks and wide-open spaces. The kids really enjoyed Moab. Adam and I went mountain biking. And we all enjoyed the sightseeing. Great rocks. We even saw some dinosaur tracks!**

**Love, Rob**

# 178.

Design mailing labels that feature your photos.

From:
Sheppard
2243 Wooden Dr,
St. Paul, MN 55444

**To:**

# 179.

Create a web page that shows off your photos for friends and family across the country (and even the world).

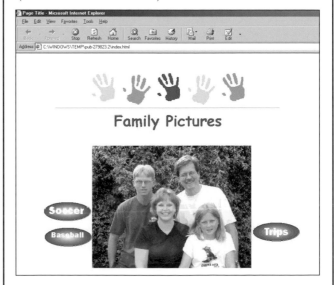

# 180.

Once you start scanning, you'll find more and more ways to use your photos. Add that to all of the photos multiplying on your hard drive, and you'll quickly understand why you need to have enough digital room to put your photos. Even if you have a super-big, multi-gigabyte hard drive, you'll still want other places to save your scans to, just for protection.

# 181.

A big hard drive is basic. Your key photos and all of your recent scans should be there so they can be quickly and easily worked on. Hard drives are relatively inexpensive for the amount of storage they offer, and they are very fast for getting images in and out of storage. Choose a hard drive based on speed and size.

# 182.

With any amount of scanning, you'll need some add-on storage. This allows you to remove images from your computer and give them to someone else, including a processing lab that can make traditional photo prints from your scans.

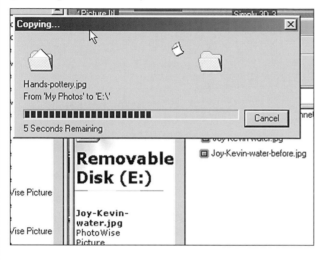

# 183.

The floppy disk has been a standard way of handling data for a long time, but it won't hold much in the way of photos. You can compress an image with JPEG compression to fit on a floppy if you really need to, but the overall image quality may be affected.

# 184.

You can replace your floppy drive with a SuperDisk drive. The SuperDisk holds 120 MB of data (a good group of photo files) and the drive will also read traditional floppies.

# 185.

The Zip disk has become a standard way many photographers transfer images to labs and publishers. It is available in both 100 and 250 MB forms.

# 186.

More and more photographers are finding that a CD-R or CD-RW drive is the way to go for backing up images. You can put over 600 MB of photo files on a single, inexpensive CD. While not as flexible as a Zip or SuperDisk (you can read a file and write it right back to them), CD's are nearly universally readable by most computers and are durable and long-lasting. Buy quality CD-Rs (not the specially priced ones) if long life is important to you.

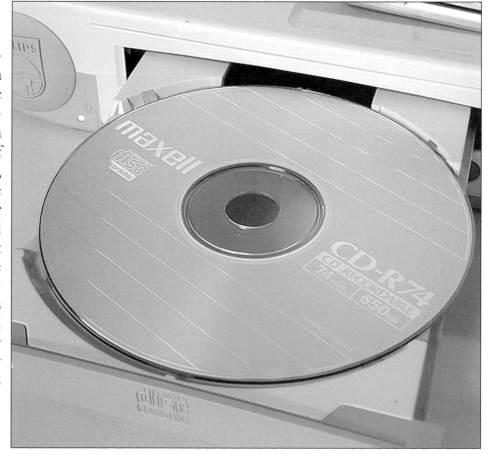

# conclusion

## 187.

A scanner frees you to be creative. You can scan photos to work on whenever you want or need them.

## 188.

A scanner does require practice to get the most out of it. Scanning is a craft and you will get better at it, the more you do it.

# Other Books from
# Amherst Media™

## Computer Photography Handbook

*Rob Sheppard*

Learn to make the most of your photographs using computer technology! From creating images with digital cameras, to scanning prints and negatives, to manipulating images, you'll learn all the basics of digital imaging. $29.95 list, 8½x11, 128p, 150+ photos, index, order no. 1560.

## Achieving the Ultimate Image

*Ernst Wildi*

Ernst Wildi teaches the techniques required to take world class, technically flawless photos. Features: exposure, metering, the Zone System, composition, evaluating an image, and more! $29.95 list, 8½x11, 128p, 120 b&w and color photos, index, order no. 1628.

## Black & White Portrait Photography

*Helen T. Boursier*

Make money with b&w portrait photography. Learn from top b&w shooters! Studio and location techniques, with tips on preparing your subjects, selecting settings and wardrobe, lab techniques, and more! $29.95 list, 8½x11, 128p, 130+ photos, index, order no. 1626.

## The Beginner's Guide to Pinhole Photography

*Jim Shull*

Take pictures with a camera you make from stuff you have around the house. Develop and print the results at home! Pinhole photography is fun, inexpensive, educational and challenging. $17.95 list, 8½x11, 80p, 55 photos, charts & diagrams, order no. 1578.

## Professional Secrets for Photographing Children

*Douglas Allen Box*

Covers every aspect of photographing children on location and in the studio. Prepare children and parents for the shoot, select the right clothes capture a child's personality, and shoot story book themes. $29.95 list, 8½x11, 128p, 74 photos, index, order no. 1635.

## Handcoloring Photographs Step-by-Step

*Sandra Laird & Carey Chambers*

Learn to handcolor photographs step-by-step with the new standard in handcoloring reference books. Covers a variety of coloring media and techniques with plenty of colorful photographic examples. $29.95 list, 8½x11, 112p, 100+ color and b&w photos, order no. 1543.

## Special Effects Photography Handbook

*Elinor Stecker-Orel*

Create magic on film with special effects! Little or no additional equipment required, use things you probably have around the house. Step-by-step instructions guide you through each effect. $29.95 list, 8½x11, 112p, 80+ color and b&w photos, index, glossary, order no. 1614.

## McBroom's Camera Bluebook, *6th Edition*

*Mike McBroom*

Comprehensive and fully illustrated, with price information on: 35mm, digital, APS, underwater, medium & large format cameras, exposure meters, strobes and accessories. Pricing info based on equipment condition. A must for any camera buyer, dealer, or collector! $29.95 list, 8½x11, 336p, 275+ photos, order no. 1553.

## Family Portrait Photography

*Helen Boursier*

Learn from professionals how to operate a successful portrait studio. Includes: marketing family portraits, advertising, working with clients, posing, lighting, and selection of equipment. Includes images from a variety of top portrait shooters. $29.95 list, 8½x11, 120p, 123 photos, index, order no. 1629.

## The Art of Infrared Photography, *4th Edition*

*Joe Paduano*

A practical guide to the art of infrared photography. Tells what to expect and how to control results. Includes: anticipating effects, color infrared, digital infrared, using filters, focusing, developing, printing, handcoloring, toning, and more! $29.95 list, 8½x11, 112p, 70 photos, order no. 1052

## Camcorder Tricks and Special Effects, *revised*

*Michael Stavros*

Kids and adults can create home videos and mini-masterpieces that audiences will love! Use materials from around the house to simulate an inferno, make subjects transform, create exotic locations, and more. Works with any camcorder. $17.95 list, 8½x11, 80p, 40 photos, order no. 1482.

## Essential Skills for Nature Photography

*Cub Kahn*

Learn all the skills you need to capture landscapes, animals, flowers and the entire natural world on film. Includes: selecting equipment, choosing locations, evaluating compositions, filters, and much more! $29.95 list, 8½x11, 128p, 60 photos, order no. 1652.

## Photographer's Guide to Polaroid Transfer

*Christopher Grey*

Step-by-step instructions make it easy to master Polaroid transfer and emulsion lift-off techniques and add new dimensions to your photographic imaging. Fully illustrated every step of the way to ensure good results the very first time! $29.95 list, 8½x11, 128p, 50 photos, order no. 1653.

## Black & White Landscape Photography

*John Collett and David Collett*

Master the art of b&w landscape photography. Includes: selecting equipment (cameras, lenses, filters, etc.) for landscape photography, shooting in the field, using the Zone System, and printing your images for professional results. $29.95 list, 8½x11, 128p, 80 b&w photos, order no. 1654.

## Photo Retouching with Adobe® Photoshop®

*Gwen Lute*

Designed for photographers, this manual teaches every phase of the process, from scanning to final output. Learn to restore damaged photos, correct imperfections, create realistic composite images and correct for dazzling color. $29.95 list, 8½x11, 120p, 60+ photos, order no. 1660.

## Creative Lighting Techniques for Studio Photographers

*Dave Montizambert*

Master studio lighting and gain complete creative control over your images. Whether you are shooting portraits, cars, table-top or any other subject, Dave Montizambert teaches you the skills you need to confidently create with light. $29.95 list, 8½x11, 120p, 80+ photos, order no. 1666.

## Black & White Photography for 35mm

*Richard Mizdal*

A guide to shooting and darkroom techniques! Perfect for beginning or intermediate photographers who want to improve their skills. Features helpful illustrations and exercises to make every concept clear and easy to follow. $29.95 list, 8½x11, 128p, 100+ b&w photos, order no. 1670.

## Watercolor Portrait Photography: The Art of Manipulating Polaroid SX-70 Images

*Helen T. Boursier*

Create one-of-a-kind images with this surprisingly easy artistic technique. $29.95 list, 8½x11, 120p, 200+ color photos, order no. 1702.

## Basic Digital Photography

*Ron Eggers*

Step-by-step text and clear explanations teach you how to select and use all types of digital cameras. Learn all the basics with no-nonsense, easy to follow text designed to bring even true novices up to speed quickly and easily. $17.95 list, 8½x11, 80p, 40 b&w photos, order no. 1706.